D0210896

THE BRITISH MUSEUM

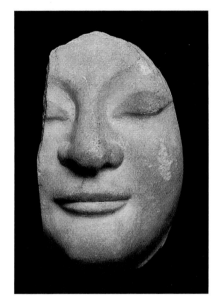

SMILE

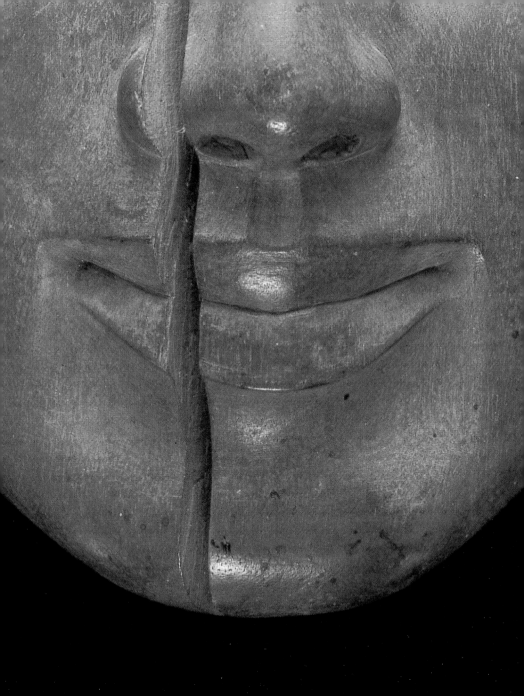

THE BRITISH MUSEUM
SMILE

MARINA VAIZEY

THE BRITISH MUSEUM PRESS

Frontispiece: Wooden funerary mask, Egypt; eighteenth Dynasty, *c.* 1400 BC.
Half-title page: Fragment of a female face from the Archaic temple of Artemis,
Greece; *c.* 550–520 BC.

Photography by The British Museum Department of Photography and Imaging

Introduction by Marina Vaizey

© 2002 The Trustees of The British Museum
First published in 2002 by The British Museum Press
A division of The British Museum Company Ltd
46 Bloomsbury Street, London, WC1B 3QQ

A catalogue record of this book is available from the British Library

ISBN 0 7141 2781 7

Designed by Peter Ward
Typeset in Centaur
Printed in Hong Kong
by C&C Offset

INTRODUCTION

THE SMILE IS UNIQUE to the human race. As far as we know, no other animal is able to create this beautiful expression. We have the most complex facial musculature of all the major primates and make use of more than seventeen muscles around the mouth and eyes when we smile. At the age of around five weeks, a baby starts to smile to ensure that its mother responds to its wishes and stays close at hand. Throughout our life we continue to use the smile as an indication that we take pleasure in other people's company and intend them no harm. For these reasons, the smile has been called the most important tool in the human gestural repertoire.

The British Museum is home to many intriguing smiles from diverse civilisations across the globe. Within the Museum, gods, lovers, children, entertainers and beauties reach out to communicate with us regardless of historical period, culture or language. Smiling usually indicates pleasure, whether it be the enjoyment of the here and now or an acknowledgement of the divine experience. But often in art as in life, the meaning of the smile may depend upon the beholder.

Kulap, the extraordinary ancestral effigies of New Ireland, appear to contemporary eyes to be smiling. These striking figures were used in ritual shelters, and were the earthly form in which the souls of the dead resided. There is a flimsy boundary between what appears to us to be a smile, and the snarl or grimace intended to induce fear or terror in the spectator.

The amazing spectrum of masks used in tribal societies to celebrate stages of life shows there can be many ambiguous

distinctions. Masks from New Caledonia were used in dances commemorating the art of war – and the finality of death. *Kanak* masks are crowned with real hair, and have bodies made from bird feathers. They have closed eyes, huge noses and mouths open in frozen grins. Grimaces, smiles or snarls are also found in the huge, open mouths of the effigies of gods from Hawaii. A great wooden bowl (p. 78) for serving the intoxicating liquor *kava* is carved in the shape of a panting, smiling beast, its mouth stretched wide, perhaps as an enticement to drink deeply.

In contrast, the famed bronzes and ivories of rulers from the kingdoms of sixteenth-century Ife and Benin are symbols of perfection. The faces are ageless and the subject's gender is identified only by the attributes of crown, headdress or hairstyle. These are idealised portraits and lack the individual features from which we usually discern character. Their expressions are serene and at times gently smiling.

An extraordinary mix of earthly and divine, natural and supernatural exists in the pantheon of Hindu gods and goddesses. The result is a rich variety of facial expression. Dancing girls and goddesses often smile. In a Thanjuvur painting, the child Krishna smiles as he plays his divine flute. In a Rajasthani painting from the eighteenth century, Krishna smiles as he watches his beloved Radha dressing after her bath on the terrace below. Saraswati, the goddess of learning and wisdom, also smiles, and all the attendants of the gods smile invitingly.

Early stone sculptures depicting the Buddha show him in seated pose, hand upraised, serenely smiling. Bodhisattvas (meaning 'one destined for enlightenment') are depicted in China and Japan in various guises including demons, devils and divinities. One of the most important bodhisattvas is Maitreya. He is the portly god of wealth, grinning and nearly laughing, to be found at the entrance to many temples. These rounded men are figures of good luck, talismans for prosperity, rather than comic characters.

Other smiling figures of prosperity are the Buddhist Yakshis. These female nature spirits are often depicted standing beneath trees, with one arm stretched upwards, posing with sumptuous smiles.

The 'Floating world' of eighteenth-century Tokyo (Edo) vividly expressed pleasure and passion in the woodblock prints of the Ukiyo-e School. This was a popular art form, using the technique of woodblock printing which had been introduced from China during the eighth century for the spread of Buddhist texts. Many of these Japanese Geishas smile with demure delight (p. 39) as they coquettishly offer pleasure.

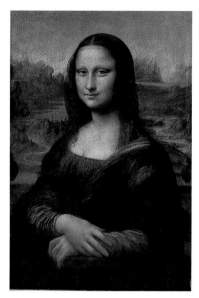

Portrait of Mona Lisa, by Leonardo da Vinci (1452-1519). Louvre, Paris.

In the Western hemisphere, the smile was not originally an expression sought in formal portraits. In the Classical and Renaissance periods smiles were seen as undignified. Statesmen, and the rich and the powerful, wished to make an impression of decorum and gravitas, grandeur and sobriety. Nonetheless, the artists of the Renaissance did portray love, love feasts and even orgies. The vast repertoire of loving glances, merriment and sheer lasciviousness was exploited, having been lent decorum by its Classical antecedents.

Perhaps the best-known smile in Western art is the most ambiguous of all. Leonardo da Vinci's *Mona Lisa* (1503-6) is utterly enigmatic: we do

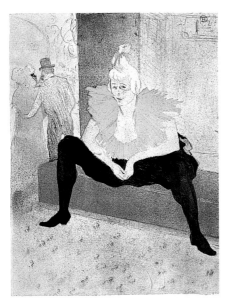

'La Clownesse',
Henri de Toulouse -Lautrec (1864–1901);
colour lithograph from the 'Elles' series, 1896.

not even know her identity. This unknown Florentine woman has been endlessly discussed, as has her smile and its meaning. The early art historian Giorgio Vasari (an entertainer himself and not always a reliable source) certainly claimed that Mona Lisa was smiling. In *Lives of the Painters*, Vasari tells us that the young woman was very beautiful, and that da Vinci engaged people to play and sing: 'and jesters to keep her merry, and remove that melancholy which painting usually gives to portraits'. The allure of her smile continues to intrigue to this day.

Western art can claim nearly a century of mirth during the Golden Age of Dutch painting in seventeenth-century Holland. The middle classes sought paintings of a domestic size, of the world they loved, their homes and their landscape. Genre paintings of the commonplace and low life also became extremely popular and were made in their hundreds.

This appreciation of the comic in art contributed to the development of caricature during the seventeenth century. It quickly became a widely popular genre precisely because it allowed much scope for the depiction of laughter, debauchery and the comic. The Italian artist Annibale Carracci (1560–1609) declared that 'a good caricature, like every

work of art, is more true to life than reality itself'.

The English artist William Hogarth (1697–1762) is perhaps best loved for his comic depictions. He was not happy to be classified as a caricaturist, but often used exaggeration as a way of dramatising his work (p. 70). His scenes of London street life are brilliantly exemplified in his pair of prints, *Beer Street* and *Gin Lane*, both held in the British Museum.

In nineteenth-century Paris, artists adored depicting entertainers, and amongst the most energetic of these was Henri de Toulouse-Lautrec (1864–1901). He was the illustrator of the cafés, theatres, cabaret singers and dancers, skilfully capturing them as the subjects of his prints and posters.

It is no doubt simpler and less ambiguous to describe a smile in words rather than in visual terms. Comedy and laughter have always featured largely in literature. The artist and poet William Blake (1757–1827) chose to illustrate mirth from Milton's *L'Allegro* in which laughter is given a human form.

Perhaps the most loved literary smile is actually a grin, immortalised not only in Lewis Carroll's prose in *Alice in Wonderland*, but also in the

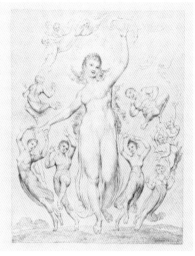

'Jest and youthful Jollity,
Quips an Cranks, and wanton Wiles
Nods and becks, and wreathèd smiles
Such as hang on Hebe's cheek,
And love to live in dimple sleek;
Sport that wrinkled Care derides
And Laughter holding both his Sides'.

William Blake (1757–1827):
Mirth from *L'Allegro* by John Milton.

9

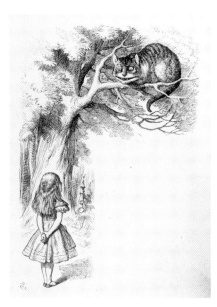

'This time it vanished quite slowly, beginning with the end of the tail, and ending with a grin, which remained some time after the rest of it had gone'.

Alice's Adventures in Wonderland,
Lewis Carroll (1832–98)
chapter 6, (1865).

illustrator John Tenniel's rendering of the Cheshire Cat. Indeed, the grin of the Cheshire Cat was so powerful that when he faded into invisibility his grin still remained.

The smile appears more and more frequently in art as artists increasingly portrayed people as individuals. These days, in the amateur photograph or snapshot, we are almost always smiling. In the frozen moment snatched by many famous photographers, smiles abound. In the celebrity culture of the twenty-first century, where people can acquire fame simply for their appearance, smiles are certainly a bright currency.

The smile is a precious commodity in art. We must treasure such smiles when we find them, as expressions of joy, serenity, delight and love.

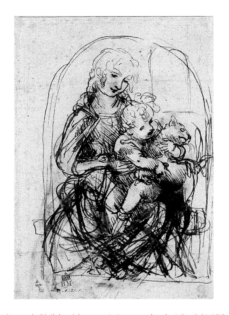

'The Virgin and Child with a cat', Leonardo da Vinci (1452–1519);
pen and ink over a sketch with stylus, detail, date unknown.

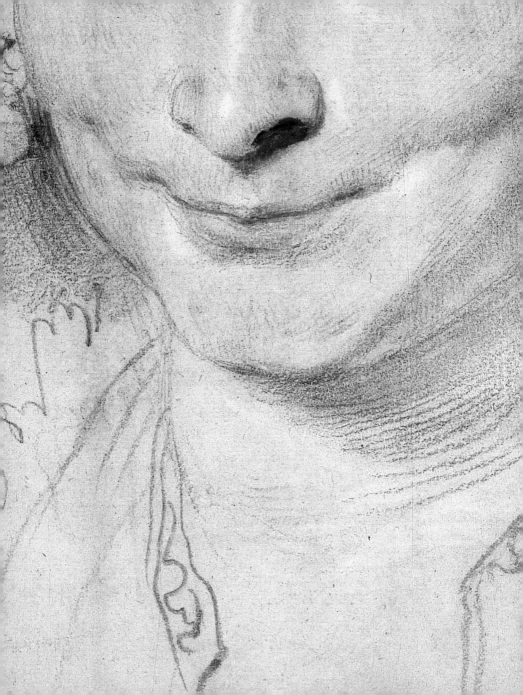

'There are only two styles of portrait painting;
the serious and the smirk.'

Nicholas Nickleby, chapter 10, Charles Dickens (1839).

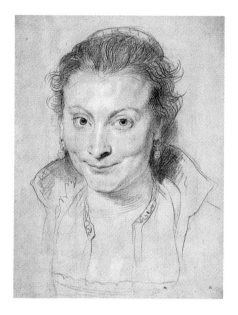

'Isabella Brant', Peter Paul Rubens (1577–1640);
coloured chalks with pale brown wash and white heightening, 1621.

This portrait drawing by Rubens is of his first wife, Isabella Brant.
Her attractive personality is made immediate through her direct stare
and warm, mischievous smile.

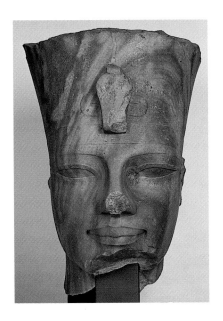

Amenhotep's lower lip curves in a perfect shallow arc up to the open
corners of his mouth, which creates the effect of a slight smile.
The complete statue, with the body, would have measured
over twenty-six feet. Its sculptors deliberately angled
the eyes downwards so that the spectator would look up and
make eye contact with this gently smiling King.

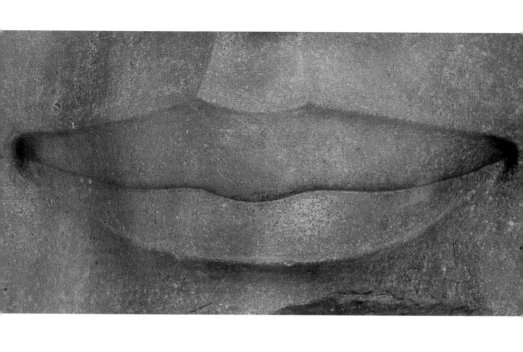

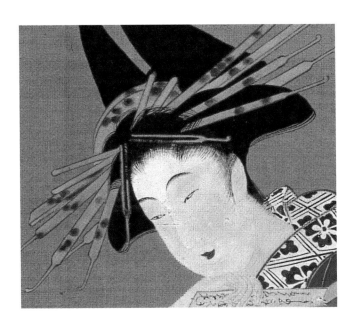

'Parody of Zhuang Zi's Dream of Butterflies', Anonymous; Japanese hanging scroll, ink colour and gold on silk, 1425.

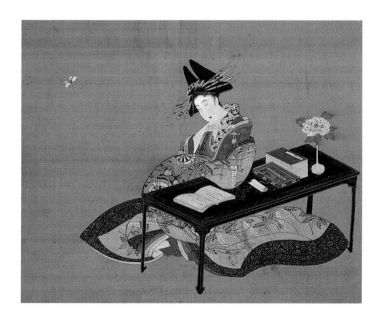

Zhuang Zi was a Chinese philosopher who studied the nature
of human consciousness within the material world.
He had a dream in which he imagined that he was a butterfly,
but on waking, could not decide if he had become the
butterfly or if the butterfly had taken on his form.

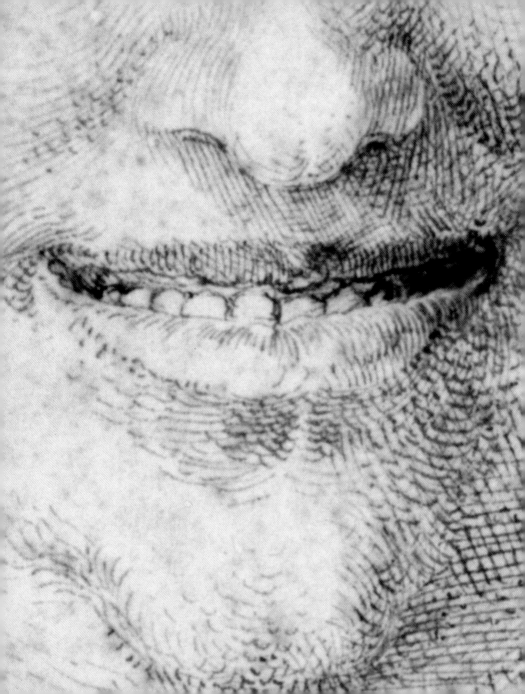

'Portrait of a Peasant Woman', Albrecht Dürer (1471–1528); pen, brown ink and brown wash, *c.* 1505–7.

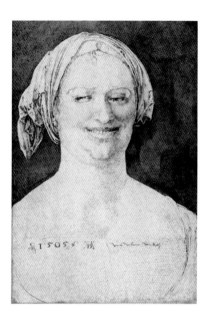

This portrait of a peasant woman is widely regarded as one of the finest of Dürer's pen portraits and conveys an infectious mirth in the smiling features of the woman.

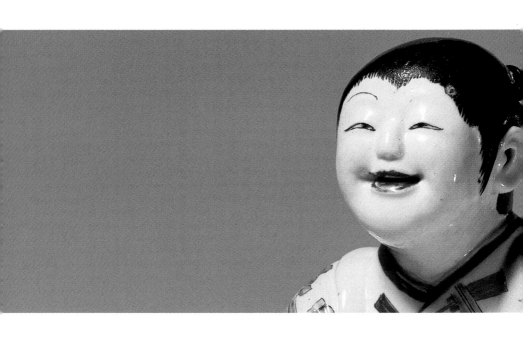

Model of a smiling boy on a *go* board, Japan, *c.* seventeenth century.

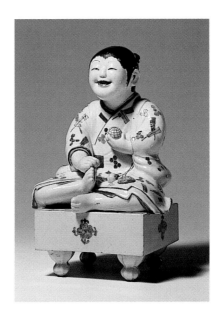

The game of *go* is designed for two players, and aficionados in Japan consider it a true art. The game was once so popular that it became a way of life, and even philosophies have been built on *go* principles.

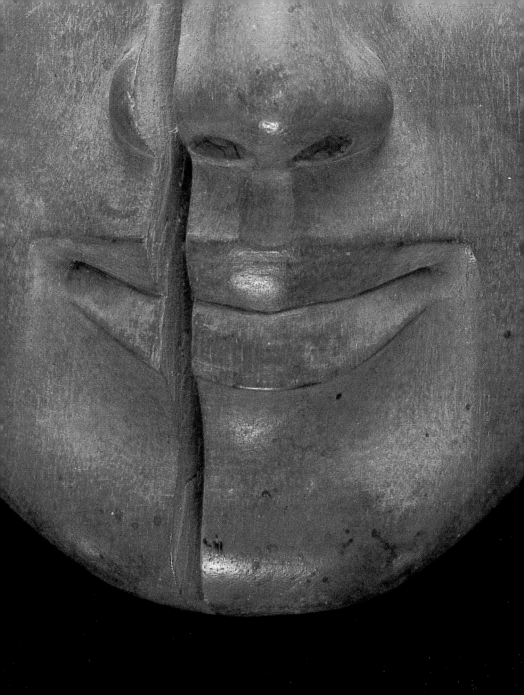

'*The* woman is perfected
Her dead
Body wears the smile of accomplishment.'

'Edge', Sylvia Plath (1963)

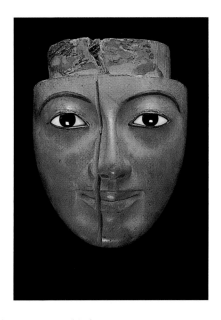

Wooden funerary face mask, possibly for a man or woman, Egypt; eighteenth Dynasty, *c.* 1400 BC.

A face mask would be inserted into a mummy case to portray the deceased owner. On this example, the exquisite features, smiling mouth and serene expression reflect the physical perfection which the individual hoped to enjoy in the eternal afterlife.

A panel painting from the Palace of Westminster, England;
c. 1263–6.

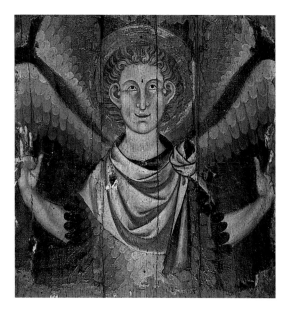

This gently smiling winged seraph is one of only two surviving
examples of English panel painting from the bedchamber of
Henry III (1216–72) at Westminster Palace. The bedchamber was largely
destroyed by a fire in 1834, but fortunately the panels had been
removed in 1816 by a workman. They were discovered in Bristol in 1993
with an inscription around their frame explaining their movements.

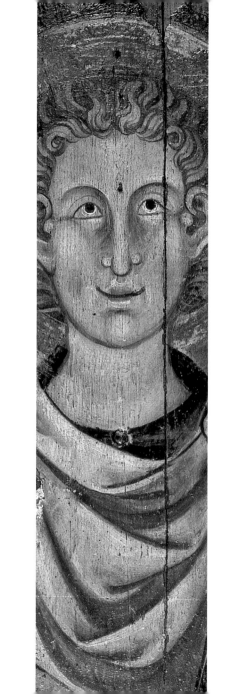

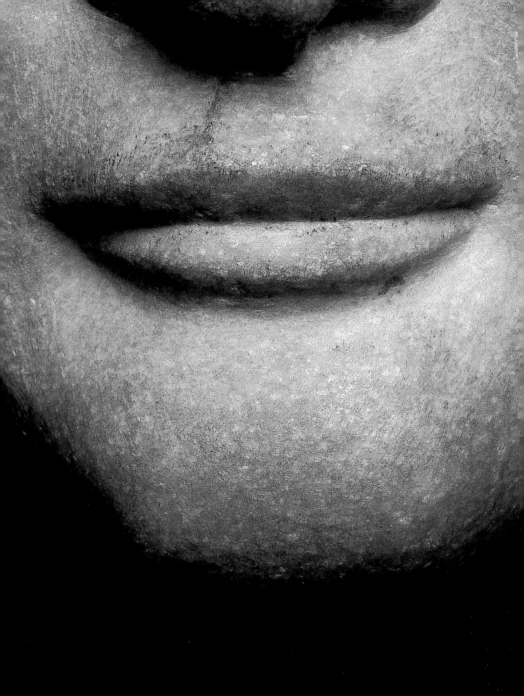

Fragment of a female face
from the Archaic temple of Artemis at Ephesos, Greece;
c. 550–520 BC.

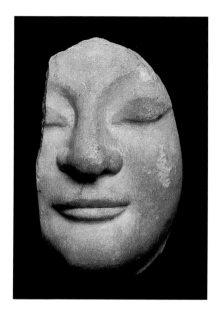

An Ionian sculptor has rendered the woman's smile
with exquisite subtlety, embedding it softly into the smooth,
rounded contours of the face.

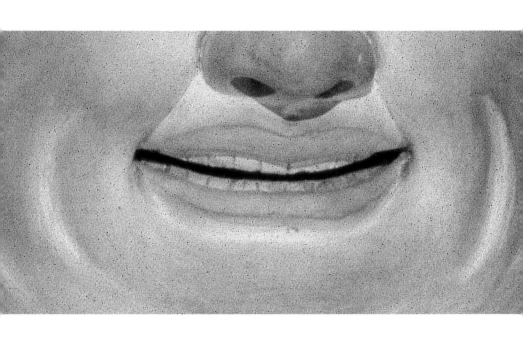

Stoneware figure of Budai ('Laughing Buddha'), from Henan Province, northern China; Ming Dynasty, 1486.

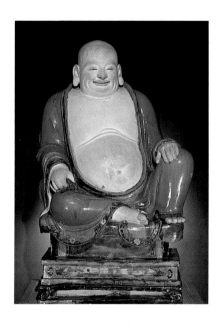

This fat, smiling Buddhist monk is a popular figure in Chinese Buddhism. He was displayed for many years in the British Museum and visitors found his rounded belly so appealing that they would often rub or touch it. As a result, some of the stoneware darkened and conservators were required to remove the dirt. The Buddha now sits in a raised position to ensure he is not touched, grinning down at the Museum's visitors.

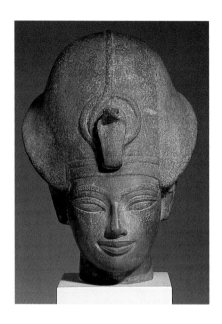

After a period of thirty years it was usual for an Egyptian king
to celebrate a jubilee known as a *sed* festival at which the
king's powers were symbolically rejuvenated. This sculpture
of Amenhotep III was created for such a festival and
portrays him with smiling, youthful features.

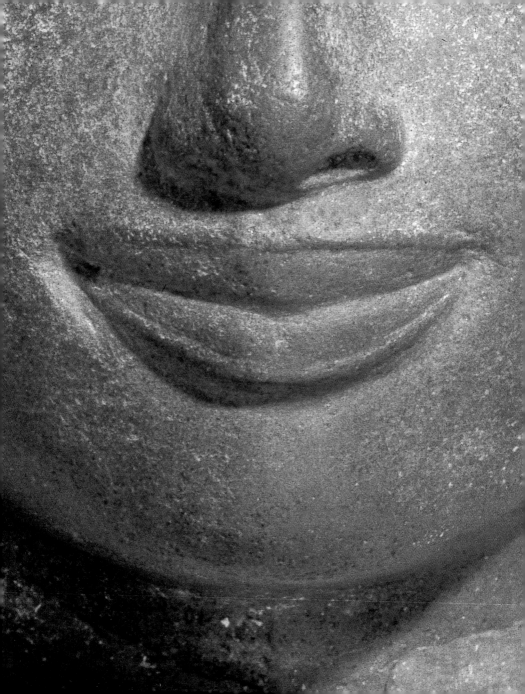

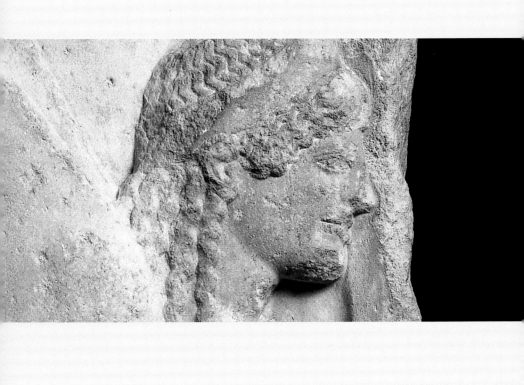

Marble relief panel from the Harpy Tomb from Xanthos in Lycia,
south-western Turkey; *c.* 470–460 BC.

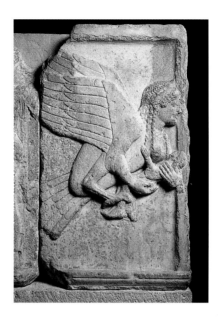

This corner relief from the Harpy Tomb shows a siren carrying away
the soul of the deceased, represented as a small human figure. The
mythical figure is aloof to human suffering.

'The Virgin and Child', Raphael (1483–1520); black chalk with white heightening, *c*. 1510–12.

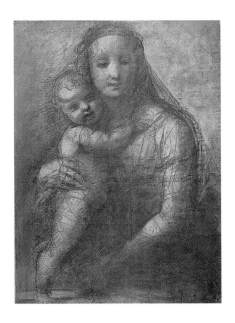

The composition of Raphael's drawing recalls the work of Leonardo da Vinci. The laughing face of the child draws in the spectator and contrasts with the serene expression of the Virgin Mother.

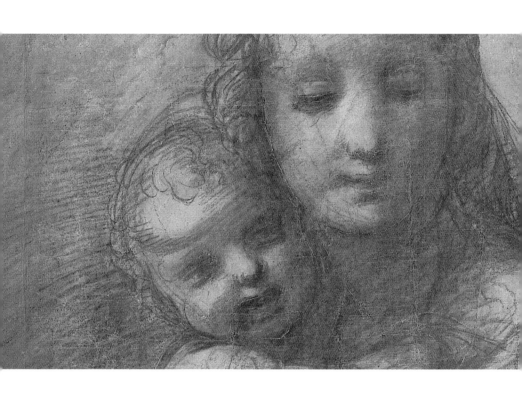

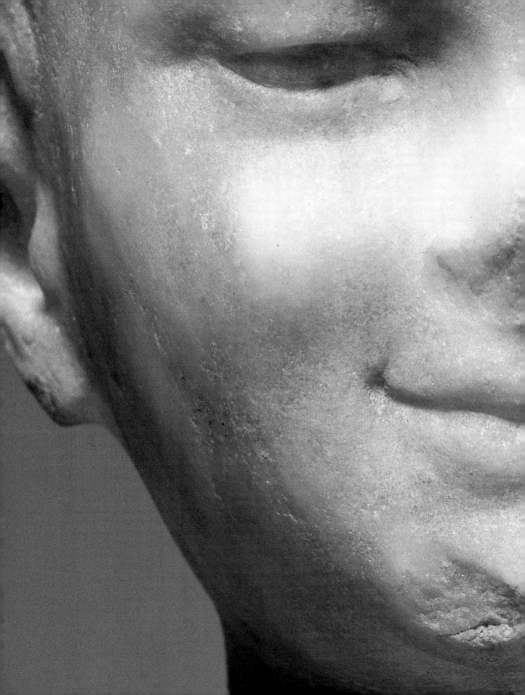

Sculpture of a young boy,
Greece; third century BC.

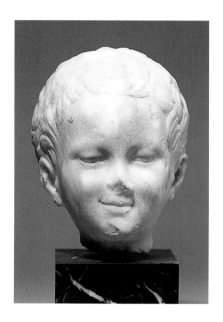

This Hellenistic sculpture of a smiling young boy bears similarities to depictions of Eros. Eros was often portrayed with a mischievous smile, causing havoc among mortals in the service of his mistress, the love-goddess Aphrodite.

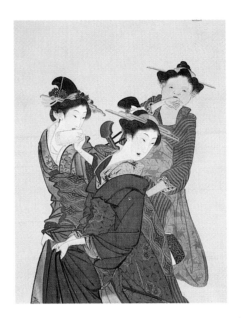

'Two Geishas with a Maid', Mori Gyokusen (1791–1864); Japanese hanging scroll, ink, colour and gold on silk, 1821.

Two geishas on their way to perform at a party are accompanied by their chubby maid. They turn to look back in surprise at something which has caught their attention, and smile with coquettish charm.

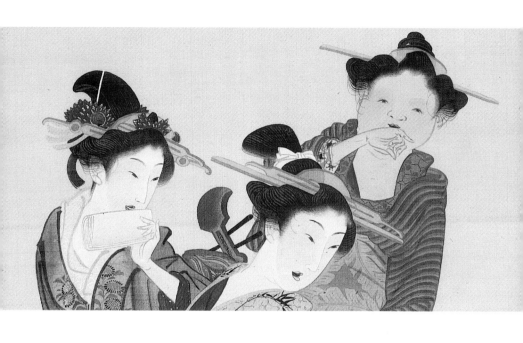

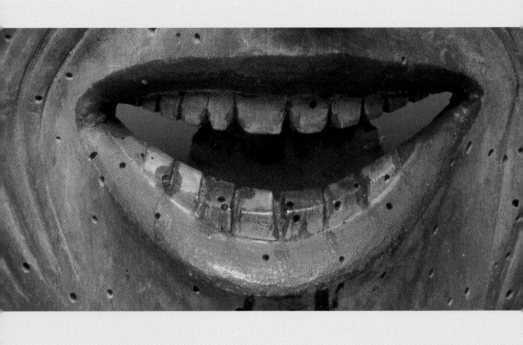

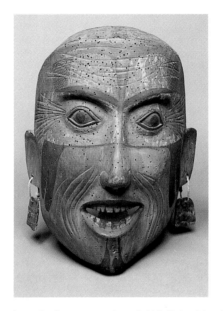

Haida wooden portrait mask of a man, northern British Columbia; nineteenth century.

The expression of surprise and pleasure on this mask is unusual. Haida portrait masks are carved to portray both ancestors and living people, and are generally impassive.

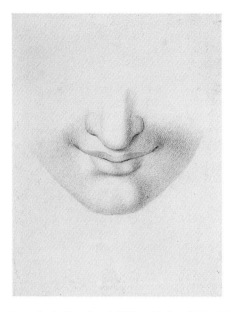

'Study of the Lower Part of a Smiling Face', William Walker (1791–1867); rust crayon on paper, date unknown.

William Walker was a well known engraver of portraits. In this drawing he has sketched a smile with beautiful simplicity.

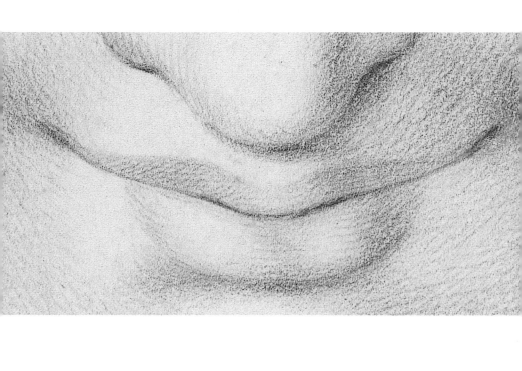

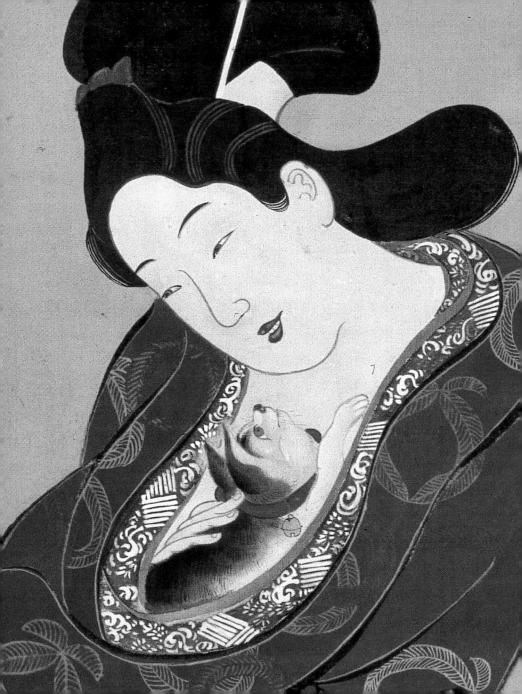

'Why do I hear
The kitten mewing for its mate
At dead of night?
Is it because he matches
My own darkening thoughts?'

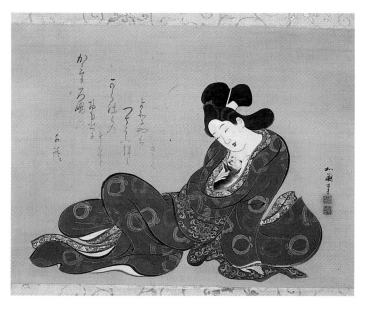

'Beauty with a Cat', Joran (dates unknown);
Japanese hanging scroll, ink, colours and gold on silk, 1597.

The poet and calligrapher Katō Chikage has inscribed a *waka* poem on
this hanging scroll suggesting the woman's thoughts, but her playful,
smiling expression hardly seems to comply with the tone of his poem.

45

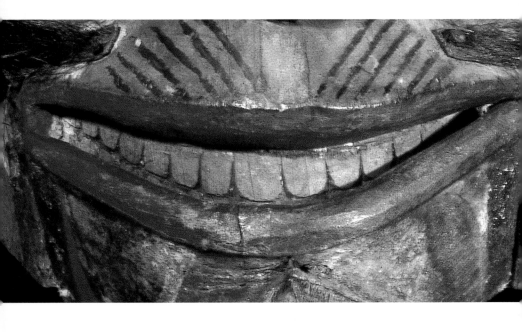

Tsimshian bear mask, northern British Columbia;
mid-nineteenth century.

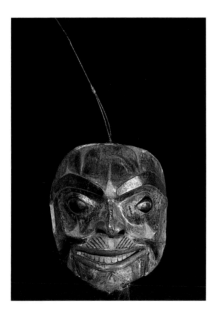

This mask was used during dances to convey the relationship between
the chief, who wore it, and supernatural ancestors. The chin is
decorated with grizzly bear skin and the moustache made from black
bear skin. The performer would manipulate the eyes and chin
expressively as the story unfolded.

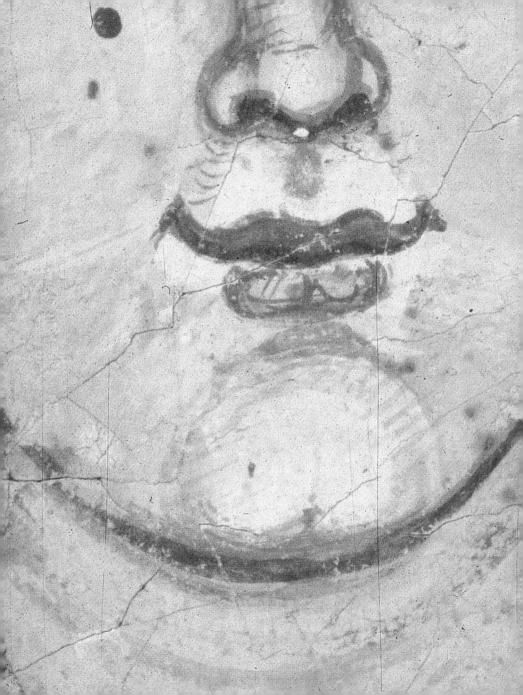

Portrait of a woman in tempera on coarse stuccoed linen,
Egypt; *c.* AD 100–20.

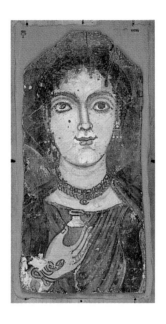

The smiling upper lip and pursed lower lip on this portrait, both
painted red, are similar to other paintings known to be from
er-Rubayat, Egypt.

Stone Head of King Thutmose III,
Egypt; eighteenth Dynasty, *c.* 1470 BC.

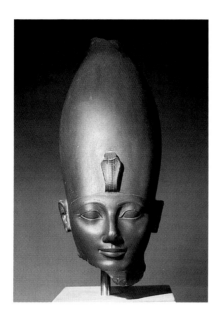

For many years it was undecided if this sculpture represented
Queen Hatshesput or her successor King Thutmose III.
The arched eyebrows and gently smiling lips are features used in
carvings of both rulers, but a detailed study of the facial features
has since confirmed the identity as Thutmose III.

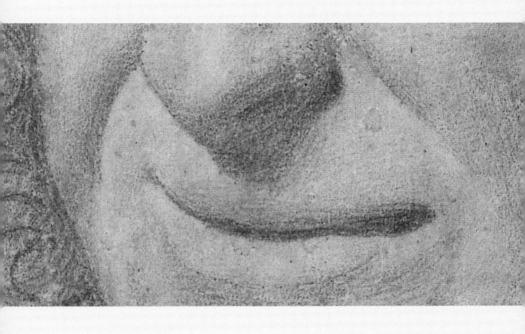

'*H*e does smile his face into more lines than are in the new map with the augmentation of the Indies.'

Twelfth Night, (Act 3, scene 2) William Shakespeare (1601).

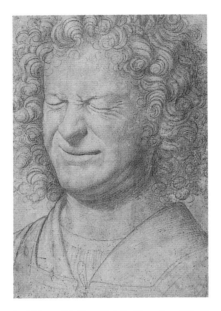

'A Curly Haired Man with Eyes Tightly Closed and Smiling Mouth',
attributed to Giovanni Agostino da Lodi (*c.* 1467–1524/5); red chalk, the contours pricked
for transfer, date unknown.

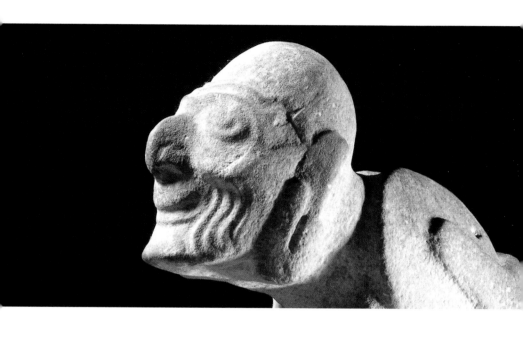

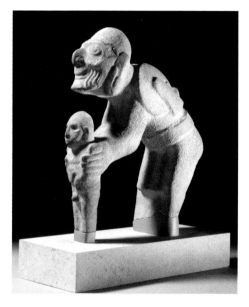

Limestone figure of an old man and a boy,
Huastec, Mexico; AD 900–1521.

It is characteristic of Huastec stone sculptures for greater detail
to be shown on the face and hands than on the rest of the body. The
three curved lines on the face of the elderly man blend effectively with
the smile, conveying a sense of paternal pride.

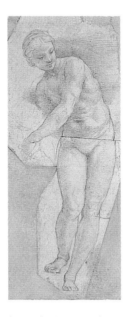

'Venus', Raphael (1483–1520); metalpoint on pink prepared surface, *c.* 1498–1520.

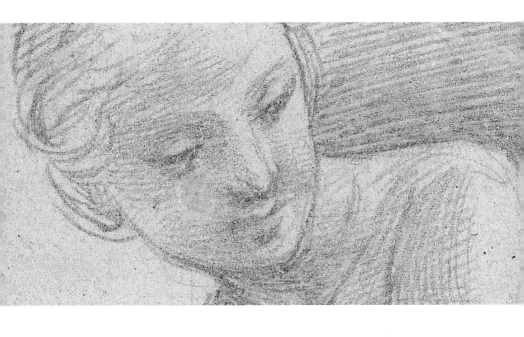

'She is Venus when she smiles,
But she's Juno, when she walks,
And Minerva, when she talks.'

'Underwoods', A Celebration of Charis in Ten Lyric pieces; His Discourse with Cupid.

Ben Johnson, (1572-1637).

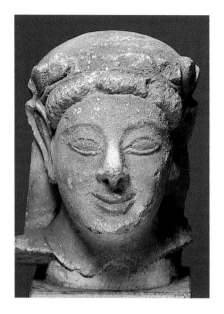

Limestone sculpture of a head, Cyprus; *c.* 490 BC.

This sculpture of a young man
shows a pronounced 'archaic smile', arguably the most enigmatic
feature of Archaic Greek sculpture.

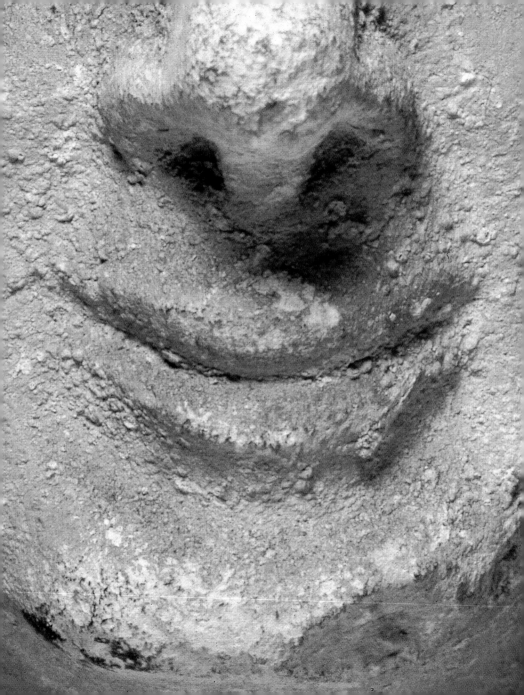

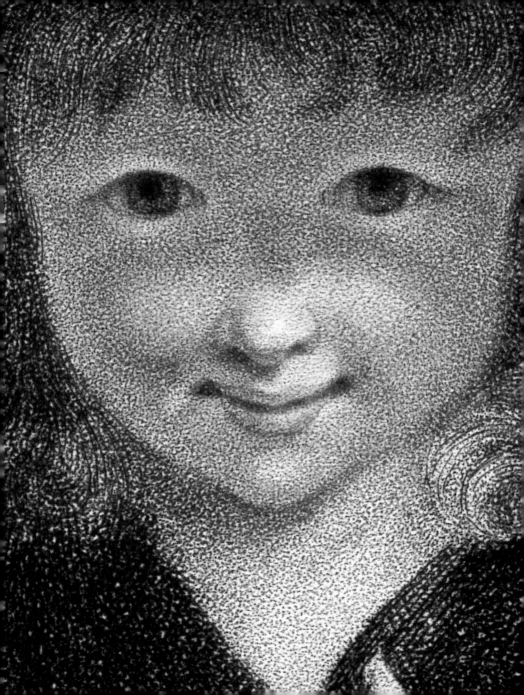

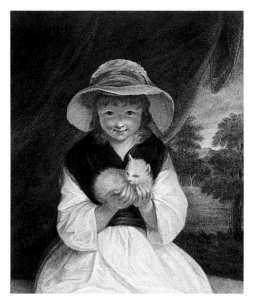

'The Girl and Kitten', Francesco Bartolozzi (1728–1815) after Sir Joshua Reynolds (1723–92); coloured print, published 1787.

Joshua Reynolds is best-known for his grand portraits of Georgian celebrities, but his paintings of children were also very popular. The young girl and her kitten were sufficiently appealing for Reynolds to paint more than one version. Bartolozzi recognised the potential popularity of the image and created a print which sold in its hundreds.

A depiction of Medusa from a red-figured hydria (water jar),
Athens; *c*. 490 BC.

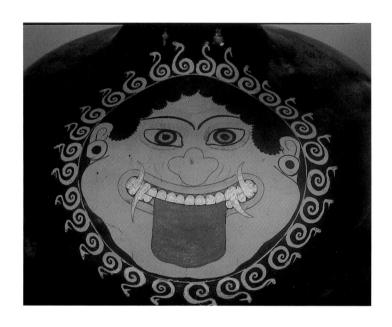

The Gorgon Medusa was a mythical monster whose
penetrating gaze turned the horrified onlooker to stone.
A manic grin reveals her teeth, fangs and protruding tongue,
her hair a nest of seething serpents.

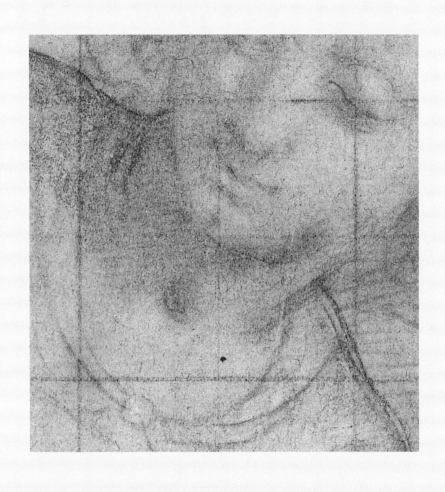

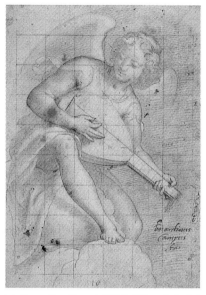

'An Angel Playing a Lute', Bernadino Campi (1522–91); red chalk heightened with white, on blue paper, squared for transfer, date unknown.

'If thou entertain'st my love, let it appear in thy smiling;
thy smile becomes thee well.'

Twelfth Night (Act 2, scene 5), William Shakespeare (1601).

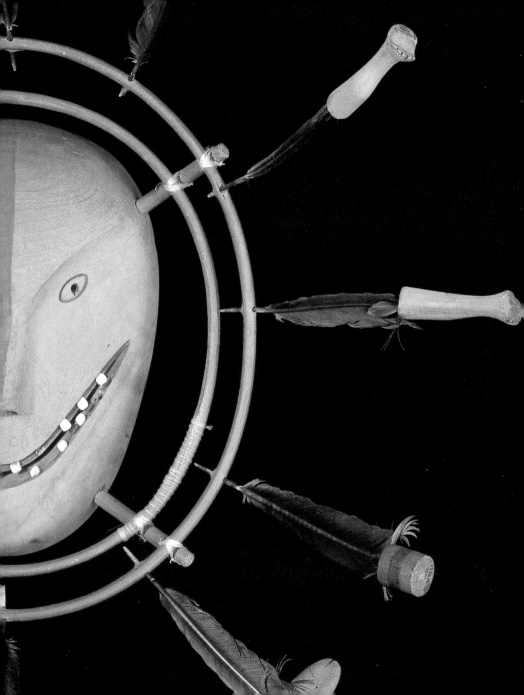

This mask represents a 'little person' or 'ircenrraq' who is part human (shown on the left) and part fox. It was made by an Alaskan Eskimo carver and may have been used by a shaman during an annual Messenger Feast to conciliate the spirits of hunted mammals so that they would return and allow themselves to be hunted.

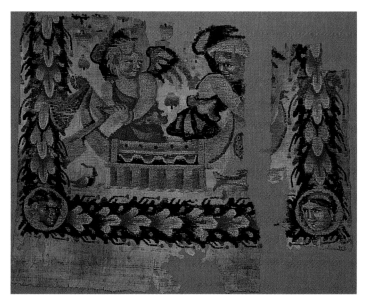

Tapestry of two cherubs in a boat, Akhmim, Egypt; fourth century AD.

This tapestry is inspired by Greek mythology and portrays
two cherubs smiling coyly at one another while
casting a fishing net overboard.

'Characters and Caricaturas', William Hogarth (1697–1764);
print published in London,1743.

Hogarth's print refers to Henry Fielding's preface to *Joseph Andrews*
(1742), where Fielding praised Hogarth as a comic history painter and
made a distinction between the comic and the burlesque in
writing, and between comedy and caricature in painting.
The print was designed to be used as a simple receipt for those who
had placed an advance order for Hogarth's series *Marriage à la mode*.

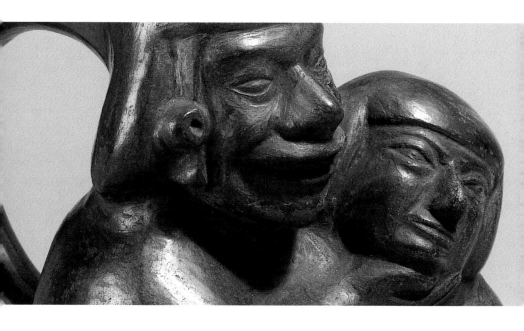

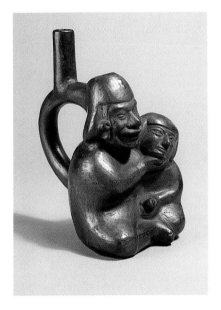

Black pottery Moche vase of two embracing figures, Mexico; AD 100–700.

This Moche vessel shows a high-ranking lord and his wife
or consort. His right hand cups her chin towards his own face and he
wears a lascivious grin of pleasure, caused by his attentive
female companion.

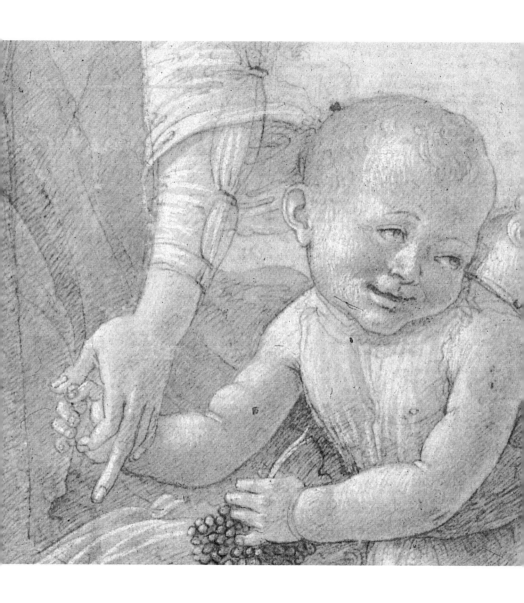

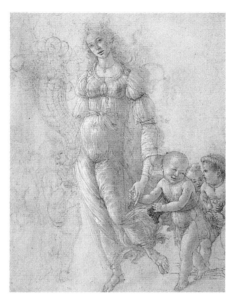

'Abundance' or 'Autumn', Sandro Botticelli (1445–1510); red and black chalk, and pen and brown ink with brown wash, *c.* 1475–82.

This is one of the finest drawings by the Florentine painter Botticelli. The female figure is believed to represent either Abundance or Autumn due to the overflowing cornucopia which she carries in her right hand. She is accompanied by young, smiling children.

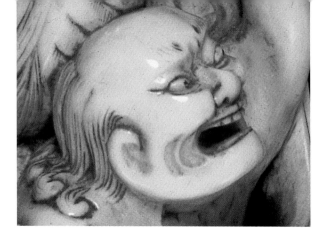

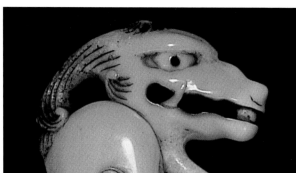

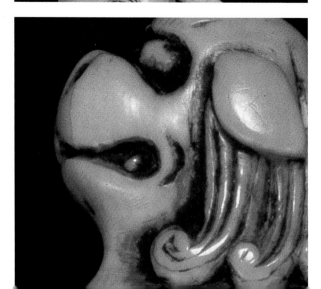

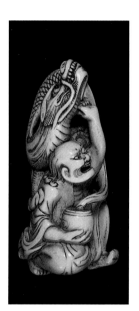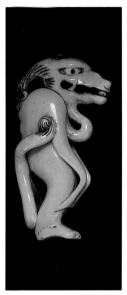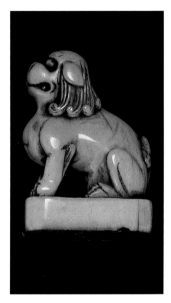

The ingenuity of netsuke carvers produced many mischievous looking characters. The objects were used as toggles to attach various kinds of bag or pouch to the belt of traditional Japanese dress. One of the Buddha's sixteen special disciples, Handaka Sonja, is shown in the figure of the crouching man who affectionately scratches the chin of his dragon whom he carries in a bowl.

The shishi (far right) was a popular figure which originated in China. In Japan pairs of shishi often guard the entrance to Shinto shrines.

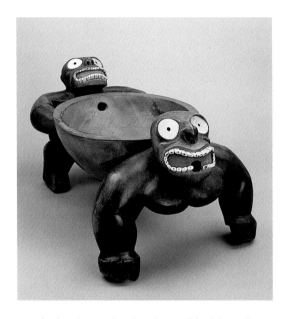

Kou wooden bowl, Hawaii, Polynesia; possibly eighteenth century.

This drinking bowl was used for preparing and serving the infusion *kava*, known to the Hawaiians as *awa*, a drink for high-ranking people made from the root of the pepper plant *Piper methysticum*. It acts as a mild sedative, relaxing both the body and the mind.

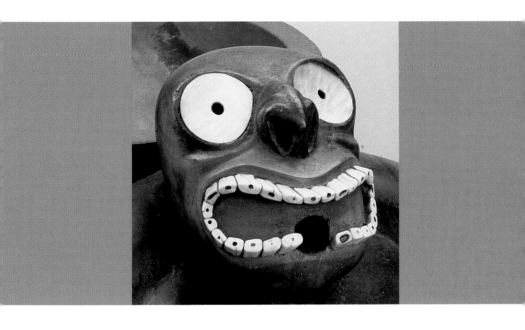

The bowl was given by a chief of Kauai to Captain Clerke who was second in command to Captain Cook during their first visit to Hawaii (1778). Cook describes the encounter in his journal: 'Captain Clerke made him some suitable presents and in return he gave him a large cava bowl, that was supported by two car[v]ed men.'

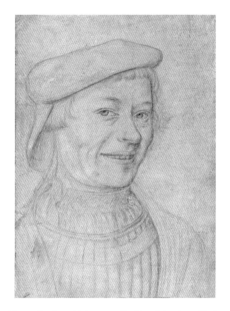

'Portrait of an Unknown Smiling Man in a Hat',
circle of Hans Holbein the Elder; metalpoint on white prepared paper, *c.* 1460–1524.

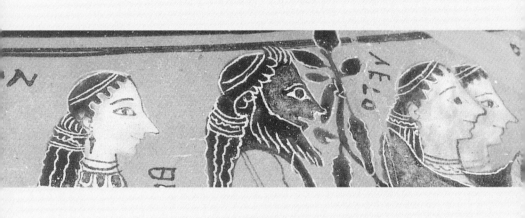

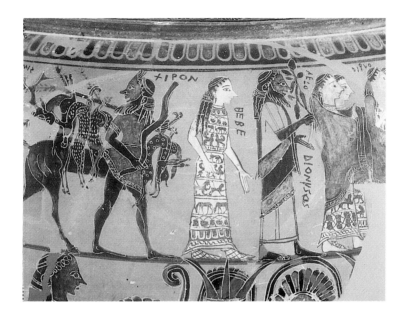

These smiling figures are guests at the mythical wedding of the mortal
Peleus and the immortal Thetis who were parents of the Greek
hero Achilles. Shown here are Chiron, the centaur, Dionysos,
the god of wine, and Hebe, the goddess of youth.
Throughout the literature of Homer, smiles are often attributed to
the gods and express consent and often sympathy for mortals.
The bowl would have been used for mixing wine.

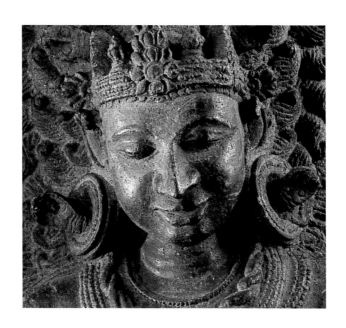

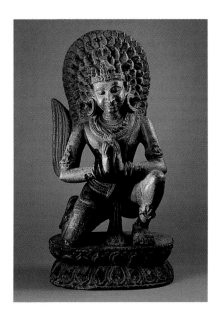

Garuda kneeling in adoration, Orissa, eastern India;
thirteenth century AD.

The servant and solar deity Garuda is depicted in a position
of adoration before his master, the Hindu god Vishnu.
His full lips are gently smiling and his eyes down-turned
as he kneels in worship.

Nō mask of a Shōjō, a mythical sprite-like creature who lives
in the water and loves to drink sake when on the land,
Japan; *c.* ninteenth century.

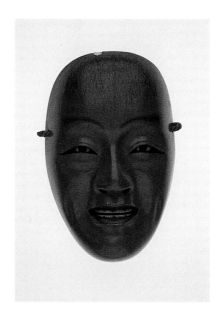

In the Japanese play *Midare*, a merchant dreams of going to market to
sell his sake. In his dream a stranger arrives and drinks a huge amount
without becoming drunk. The merchant discovers that the stranger is
in fact a Shōjō who then rewards him for his generosity with
a flagon of sake which never runs dry. The Shōjō performs a lively
dance with a red wig and costume which emphasises the redness of the
mask and symbolises drunkeness.

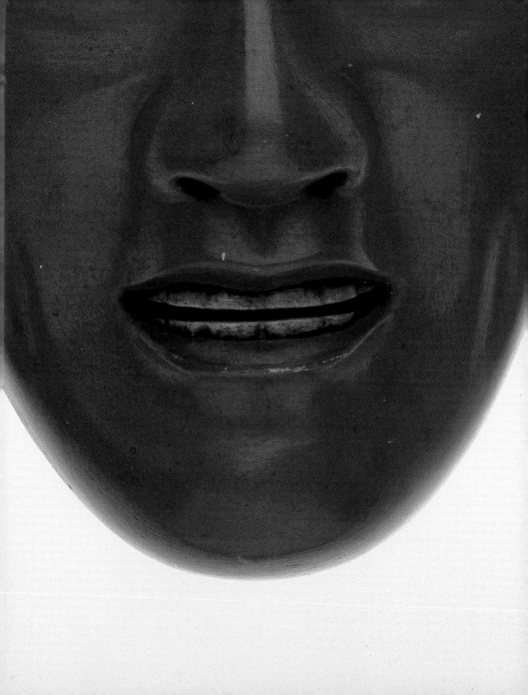

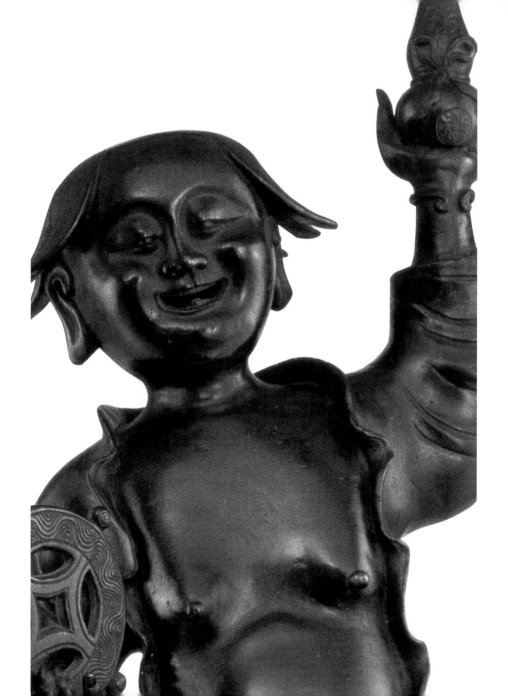

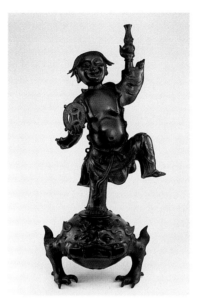

Bronze figure of the immortal Liu Hai,
China; Qing Dynasty, 1723.

The beaming Liu Hai is associated by the Chinese with wealth
and prosperity. He holds coins in his hands and stands on
a three-legged toad who has whiskers, fangs and bird feet.
The toad is associated with mortality and grins
almost as much as the figure of Liu Hai.

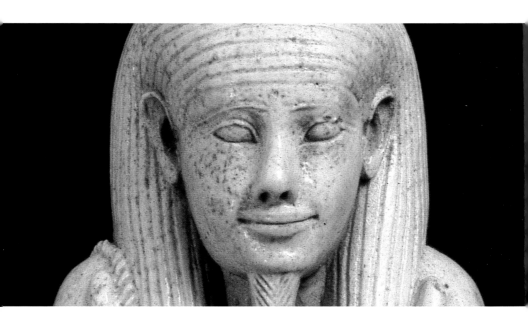

Shabti of Neferibre-sa-Neit, Egypt; twenty-sixth Dynasty, *c.* 550 BC.

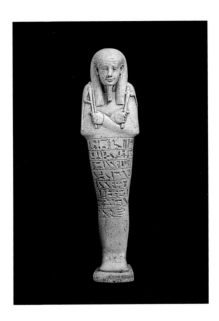

The hieroglyphic text carved on the body of this shabti
comes from the Saite version of *The Book of the Dead.* It tells of
the formula which will bring the figure to life in order to work on its
owner's behalf in the afterlife.

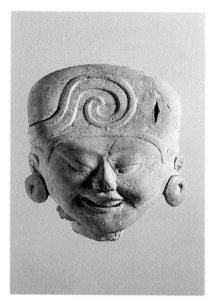

Pottery smiling head, Veracruz, Mexico; AD 300–1200.

Smiling and laughing ceramic figurines with outstretched arms
have been found with burial groups surrounding high status burials
in southern Veracruz, Mexico. It is thought that they may represent
individuals who were given an inebriating potion before
being sacrificed to accompany the deceased.

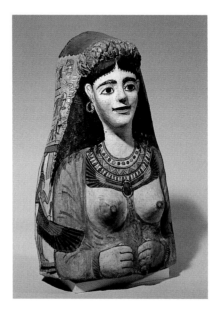

Painted plaster cartonnage mask of a woman,
Egypt; *c.* AD 100–20.

This mummy mask is elaborately decorated with a headdress,
jewellery, and motifs of Egyptian gods. The contrast of her bare chest
with the ornate decoration may cause amusement to a modern eye.

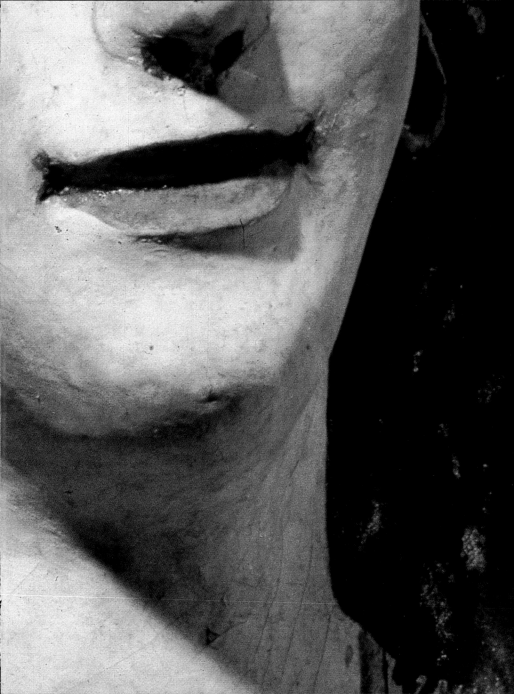

ILLUSTRATION REFERENCES

British Museum objects appear by courtesy of The Trustees of The British Museum and the Department of Photography and Imaging.

Page

1,	BM, G&R Cat Sculpture B89
2, 23	BM, EA 6887
7,	Mona Lisa © Photo RMN Lewandowski/LeMage/Gattelet
8,	BM, P&D 1949-4-11-3635
9,	BM, P&D 1918-4-13-7
10,	BM, P&D 1913-4-15-181 (346)
11,	BM, P&D 1856.6.21.1
12, 13	BM, P&D 1893-7-31-21
14, 15	BM, EA 7
16, 17	BM, JA 1913.5-1.0406
18, 19	BM, P&D 1930-3.24.1
20, 21	BM, JA 1065
22, 23	BM, EA 6887
24, 25	BM, M&ME 1995.4-1.1
26, 27	BM, G&R Cat Sculpture B89
28, 29	BM, OA 1937.13.1
30, 31	BM, EA 30448
32, 33	BM, G&R 1848.10-20.1
34, 35	BM, P&D 1894-7-21-1
36, 37	BM, G&R Cat Sculpture 1934
38, 39	BM, JA 1982.5-18.01
40, 41	BM, Ethno 1947. M6.1
42, 43	BM, P&D 1874-4-11-73..72
44, 45	BM, JA 1881.12-10.01705
46, 47	BM, Ethno Mask 217
48, 49	BM, EA 63395
50, 51	BM, EA 986
52, 53	BM, P&D 1895-9-15-481
54, 55	BM, Ethno 1985.Am.30.1
56, 57	BM, P&D 1895-9-15-629
58, 59	BM, G&R Cat Sculpture 110
60, 61	BM, P&D 1831-12-12-19
62, 63	BM, G&R Cat Sculpture E180
64, 65	BM, P&D 1895-9-15-746
66, 67	BM, Ethno 1976, M3.79A-N
68, 69	BM, EA 20717
70, 71	BM, P&D 1848-11-25-209
72, 73	BM, Ethno 1924,10-28
74, 75	BM, P&D 1895-9-15-447
76, 77	BM, (From left to right on p77) JA 1930.12-17.75, JA F817, JA 1891.9-5.24
78, 79	BM, Ethno HAW 46
80, 81	BM, P&D 1900.04.11-1
82, 83	BM, G&R 1971.11-1.1
84, 85	BM, OA 1872.7-1.67
86, 87	BM, JA 1945.10-17.506
88, 89	BM, OA 1992.6-12.1
90, 91	BM, EA 64347
92, 93	BM, Ethno 1975.Am8.3
94, 95	BM, EA 29476

With special thanks to Lissant Bolton, Catherine Edwards, the Ethnography Students Room, Victor Harris, Jonathan King, Colin McEwan, Thorsten Opper, Mavis Pilbeam, the Photography and Imaging Department, the Prints and Drawings Department, Alan Scollan, John Taylor and Tania Watkins.

Extract from 'Edge' by Sylvia Plath reproduced by kind permission of Faber and Faber Ltd.